I go into the wilderness to bear
the burden of too much beauty.

—SUSAN ZWINGER

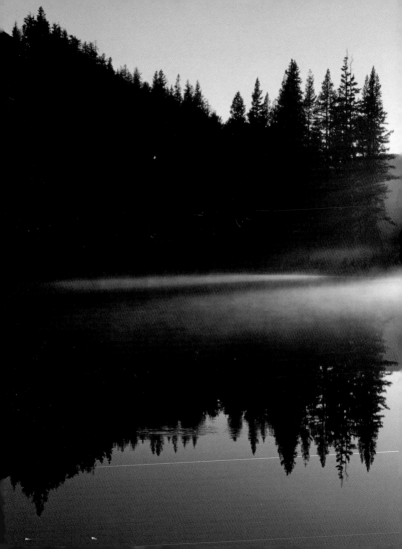

Yosemite Meditations *for* Women

PHOTOGRAPHS BY MICHAEL FRYE
EDITED BY CLAUDIA WELSH
FOREWORD BY LORRAINE ANDERSON

YOSEMITE CONSERVANCY
YOSEMITE NATIONAL PARK

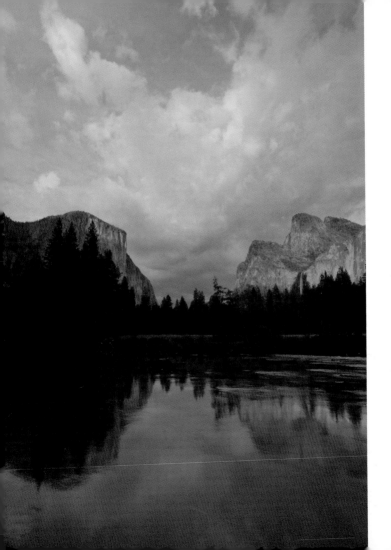

FOREWORD

Yosemite National Park is a place of transcendent beauty in the middle of what John Muir called the "Range of Light." For those who visit with the eyes to see and the ears to hear, it is an invitation to return to our true nature. Stirred by the music of Yosemite's moving waters, the majesty of its granite faces, the lushness of its forests and meadows, the abundance of its animal life, the radiance of its mountain air, we remember how securely woven into this web of life we are. We rest for a time in the vast freedom of that knowledge.

How hard our everyday world tries to make us forget! We are pushed and pulled by cultural forces that drown out our innate wisdom about the basic ingredients of sanity. Here in this book, women's voices celebrate the way back home to what is good and wild and healing. The luminous photographs of Michael Frye capture Yosemite vistas that resonate with these women's words and quiet the heart.

May these pages remind you of what matters and restore your tranquility while inspiring you to take special care of yourself and your own spot on earth.

LORRAINE ANDERSON
DAVIS, CA

Sunset, Gates of the Valley
Previous spread: Pond and mist at sunset, Tuolumne Meadows

Each woman goes out into the wilderness at a different level—from hanging from rock faces by one's toes, to barreling down dangerous whitewater, to quietly studying an insect going about its curiously wonderful business.

—SUSAN ZWINGER

Taking in the view at Taft Point

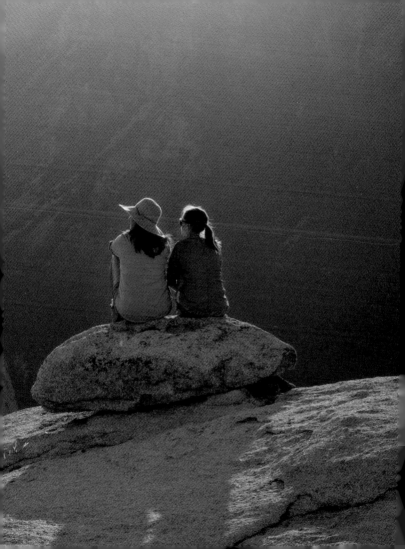

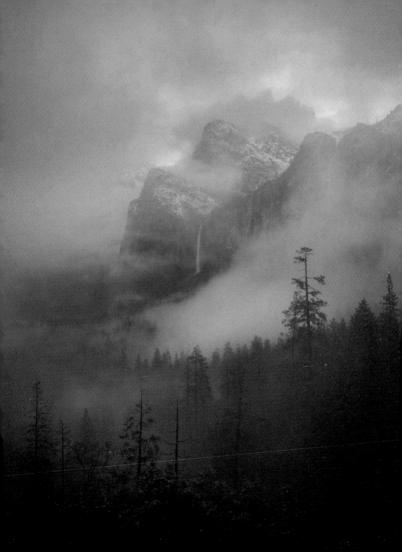

Whenever you go somewhere
that speaks to your soul,
you are going home to yourself.

—MARTHA BECK

Misty sunset over Bridalveil Fall

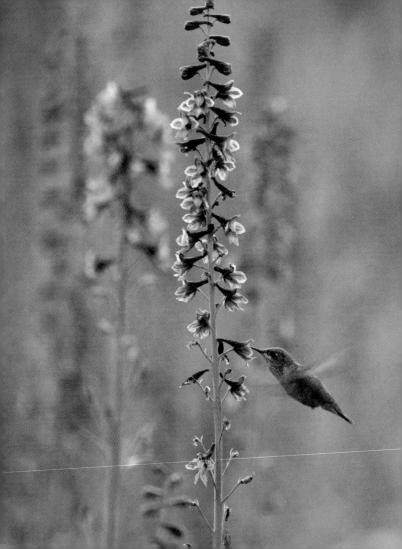

All my life through,
the new sights of nature
made me rejoice like
a child.

—MARIE CURIE

Hummingbird and larkspur

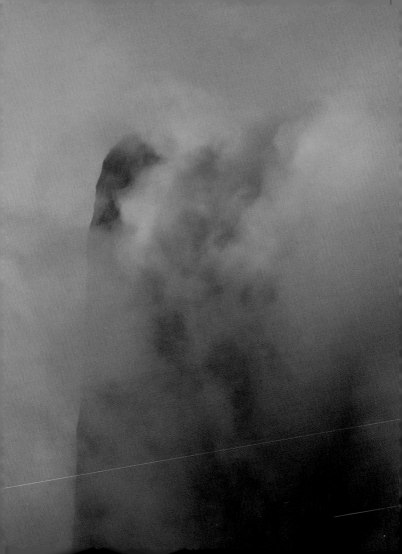

Our deepest fear is not that we are inadequate.
Our deepest fear is that we are powerful
beyond measure.

—MARIANNE WILLIAMSON

Sunset clouds, El Capitan

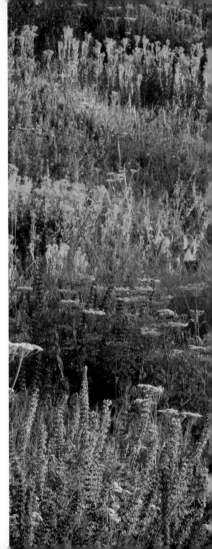

As long as we have
the meadow, there is
much left that is good
in our world.

—ELIZABETH STONE O'NEILL

Wildflowers in late afternoon light

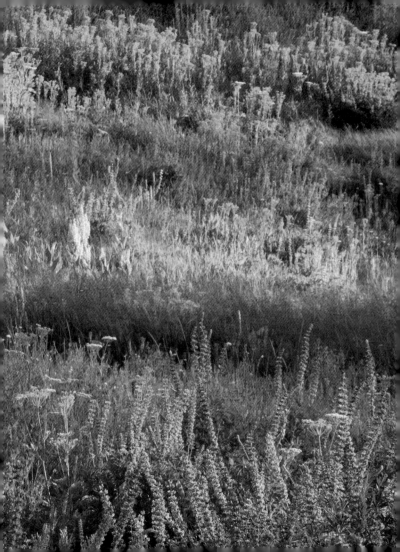

... anything's possible if you've got enough nerve.

—J.K. ROWLING

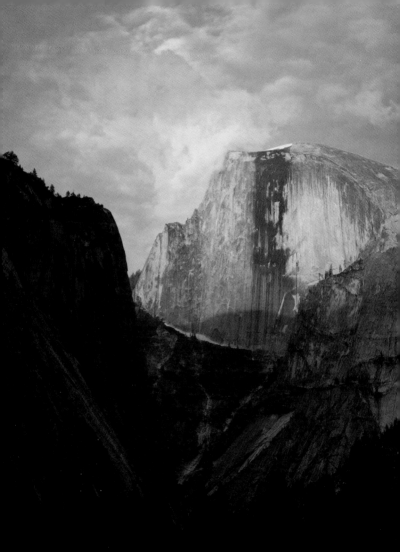

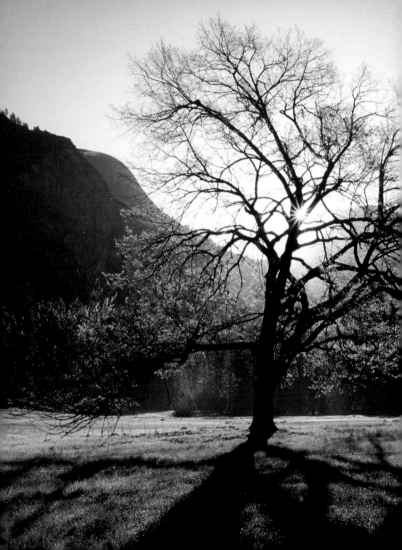

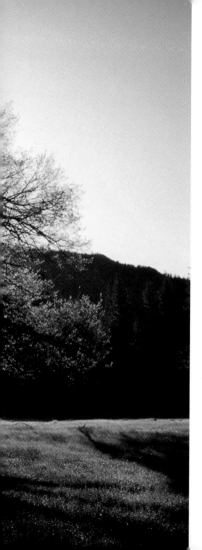

If the sight of the blue skies
fills you with joy, if a blade
of grass springing up in the
fields has power to move you,
if the simple things of nature
have a message that you
understand, rejoice, for your
soul is alive.

—ELEONORA DUSE

Elm tree at sunrise, Cook's Meadow

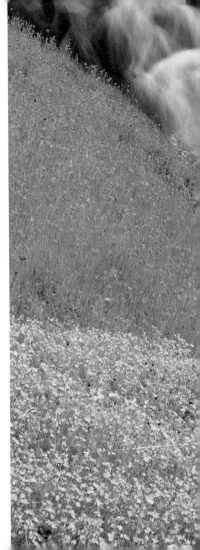

I WILL be the gladdest thing
 Under the sun!
I will touch a hundred flowers
 And not pick one.

—EDNA ST. VINCENT MILLAY

*Wildflowers above the South Fork of
the Merced River.*

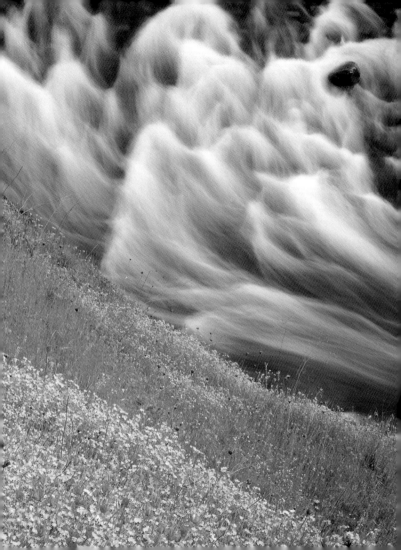

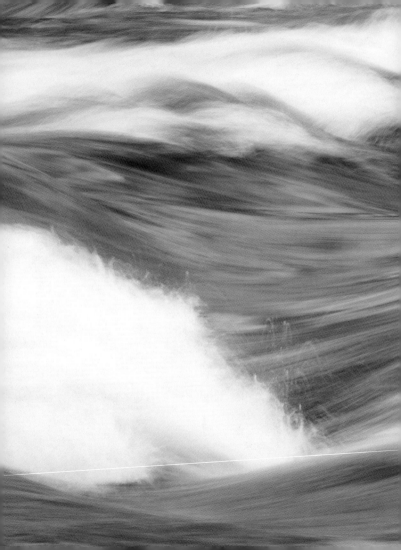

Curve: The loveliest distance between two points.

—MAE WEST

Redbud reflection, Merced River

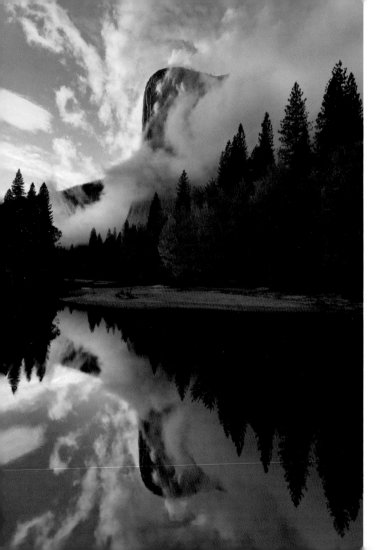

The ground we walk on, the plants and creatures, the clouds above constantly dissolving into new formations—each gift of nature possessing its own radiant energy, bound together by cosmic harmony.

—RUTH BERNHARD

Cloud formations, El Capitan and the Merced River

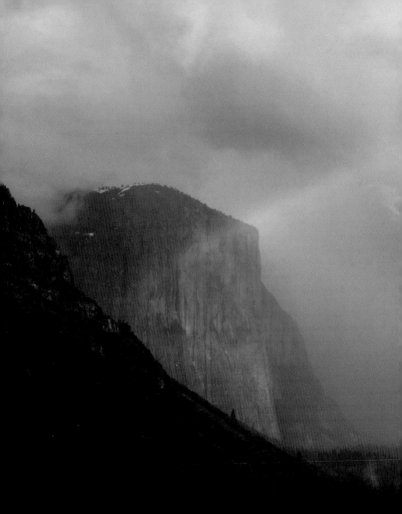

Rainbow from Tunnel View

It seemed to me as I gazed, that here was
 Nature's last, most cunning hiding-place for her
 utmost sublimities, her rarest splendors.
Here she had worked her divinest miracles with
 water and sunlight, lake, river, cataract, cascade,
 spray, mist, and rainbows by the thousand.

—GRACE GREENWOOD

Having a landscape to oneself is an exclusive pleasure. Many of us stumble on this by surprise. Suddenly it is there—unshared, solitary. One may well experience a reckless moment of freedom, a penetrating moment of understanding. A meaning that was elusive is suddenly clear!

—MARGARET OWINGS

Photographer at Tenaya Lake

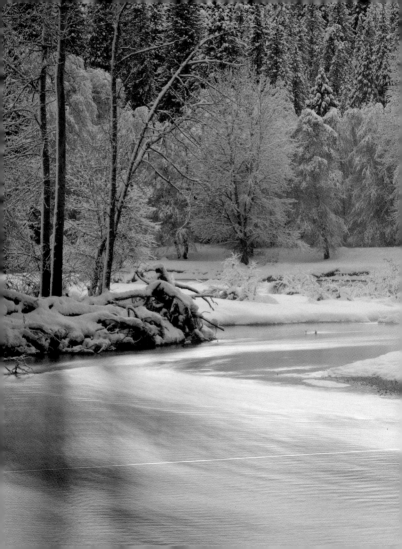

... I can never forget where I come from. My soul should always look back and wonder at the mountains I had climbed and the rivers I had forged and the challenges which still await down the road.

—MAYA ANGELOU

Golden reflections in the Merced River

You're not broken.
You don't need fixing.
Perfection is your foundation
(just peel back the layers).

—DANIELLE LAPORTE

Corn lily leaves

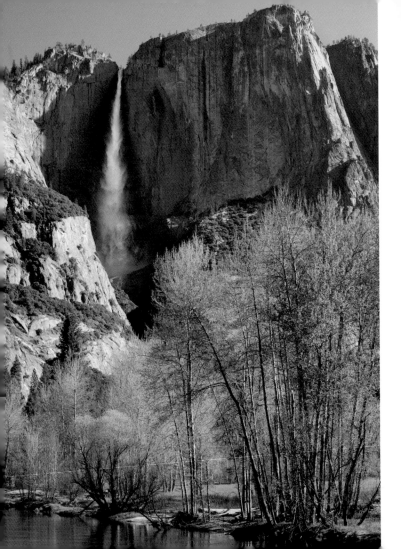

Nature has been for me,
 for as long as I remember,
a source of solace, inspiration,
 adventure, and delight;
 a home, a teacher, a companion.

—LORRAINE ANDERSON

Upper Yosemite Fall and the Merced River

Earth's crammed with heaven. …

—ELIZABETH BARRETT BROWNING

Red-winged blackbird and cow parsnip

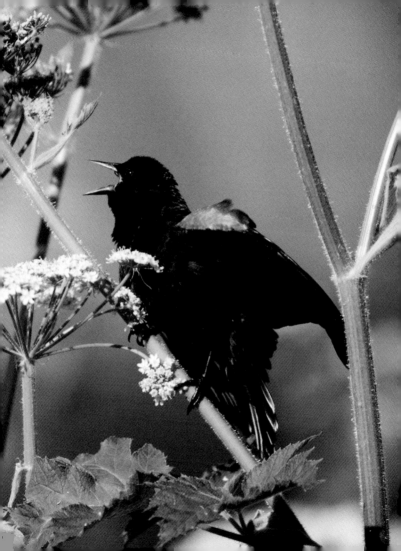

... If the earth laughs in flowers
then it smiles equally in birdsong.
It trembles at orange sunrise
and sits down in relief at the end of the day
to tell stories to the moon. ...

—ANNIE BARRETT CASHNER

Full moon setting over Middle Gaylor Lake at dawn

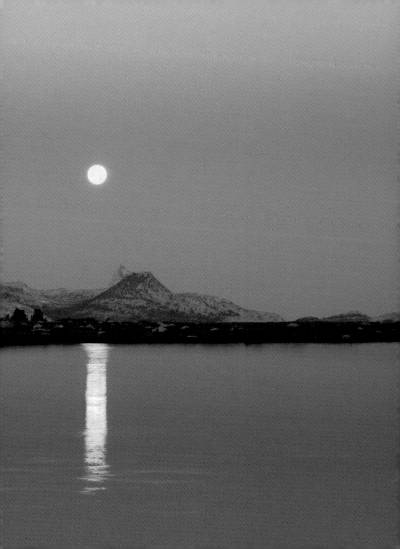

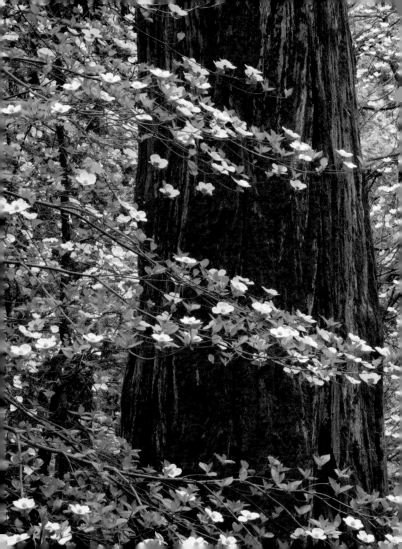

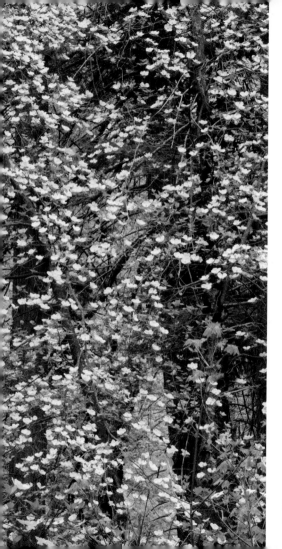

Dreams
are necessary
to life.

—ANAÏS NIN

*Dogwood blossoms and
white fir trunk*

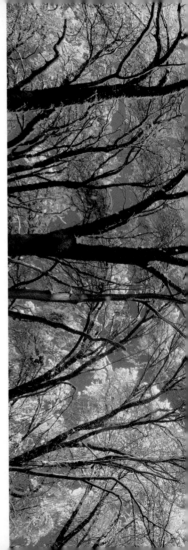

Out of solitude may grow
a sharper perception of the
quiet life about us, a deeper
appreciation of its features,
a fuller understanding of
the world's wild beauty.

—CHARLOTTE MAUK

Snowy oaks, El Capitan

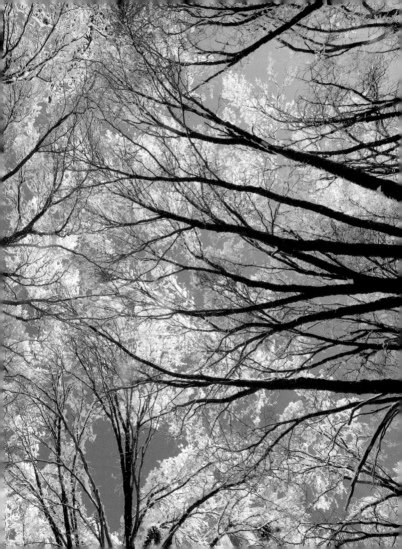

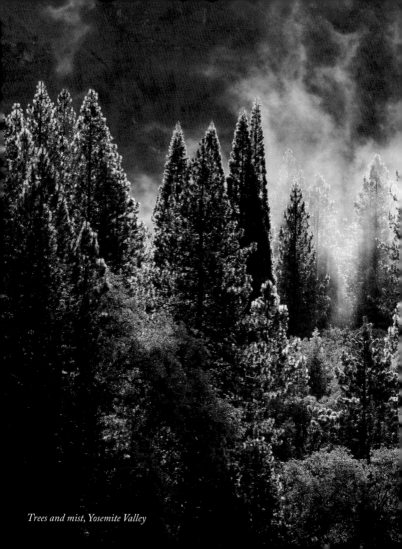

Trees and mist, Yosemite Valley

Write your story,
sing your song,
illuminate your vision
of the natural world.
That we may better see
our relation with Nature,
experience its gifts to us,
and deepen our love
and care for the earth.

—BONNIE GISEL

It began in mystery and
it will end in mystery,
but what a rare and
beautiful country lies
in between.

—DIANE ACKERMAN

Juniper and star trails near Olmsted Point

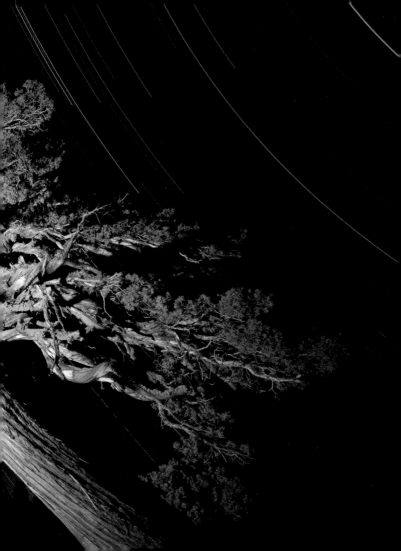

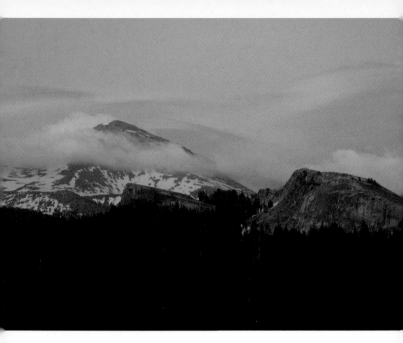

Mt. Dana, Mt. Gibbs, Lembert Dome, and lenticular clouds at sunset

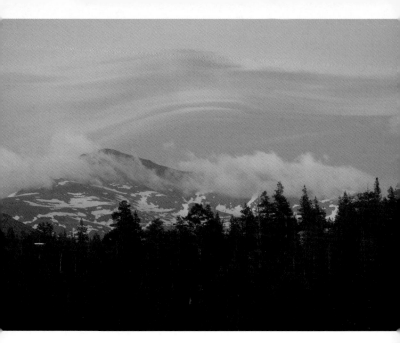

A woman can't survive
by her own breath
alone
she must know
the voices of mountains ...

—JOY HARJO

And the day came,
when the risk
to remain tight
in a bud
was more painful
than the risk
it took
to blossom.

—ANAÏS NIN

California poppies

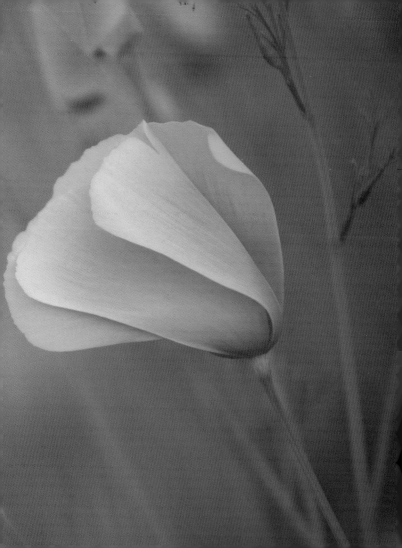

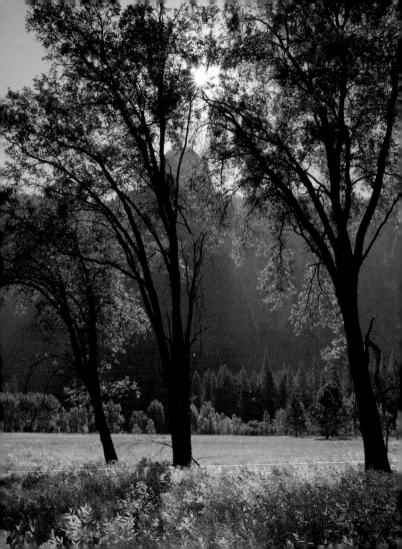

We take from the earth with a please
and we give to the earth with a thank you.

—JULIA PARKER

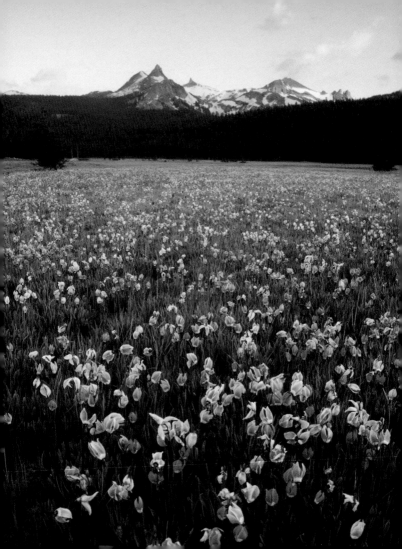

To rise above tree line is to go above thought, and after, the descent back into birdsong, bog orchids, willows, and firs is to sink into the preliterate parts of ourselves.

— GRETEL EHRLICH

Shooting stars and Unicorn Peak, Tuolumne Meadows

It is this belief in a power larger than myself
and other than myself which allows me to venture
into the unknown and even the unknowable.

—MAYA ANGELOU

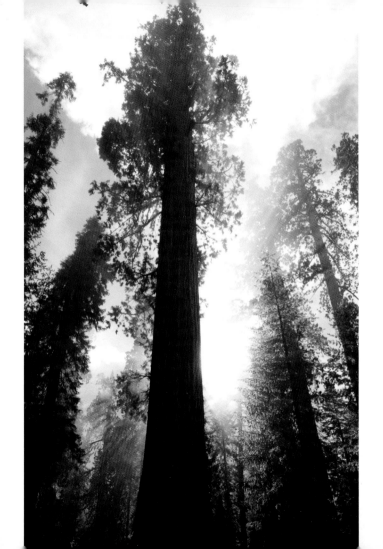

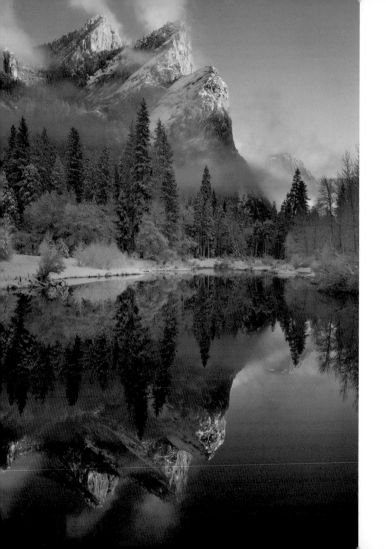

Yosemite gives people the opportunity to slow down and experience who they really are.

—SHAUNA POTOCKY

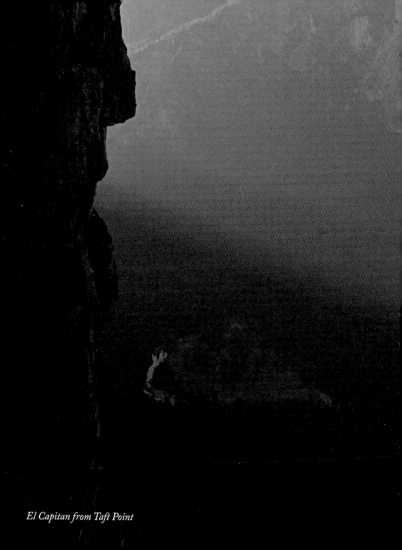

El Capitan from Taft Point

Should you shield the canyons
from the windstorms you would never see
the true beauty of their carvings.

—ELISABETH KÜBLER-ROSS

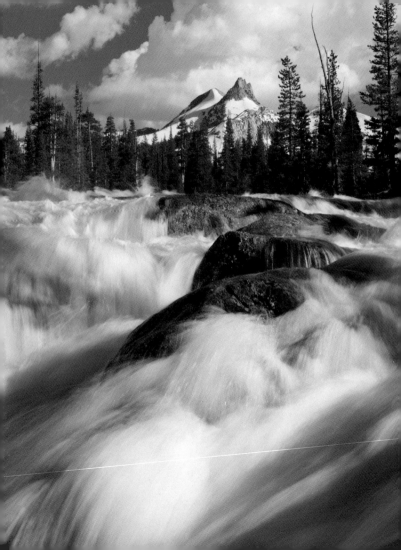

For me the sun on my face
 will always be a blessing,
the sound of running water
 a comforting hymn,
the voice of the wind
 a benediction,
and the blue sky
 an aspiration.

—BETH PRATT

Tuolumne River cascade and Unicorn Peak

Of all the things I'd been skeptical about,
I didn't feel skeptical about this:
the wilderness had a clarity that included me.

—CHERYL STRAYED

Spring morning, Yosemite Falls and the Merced River

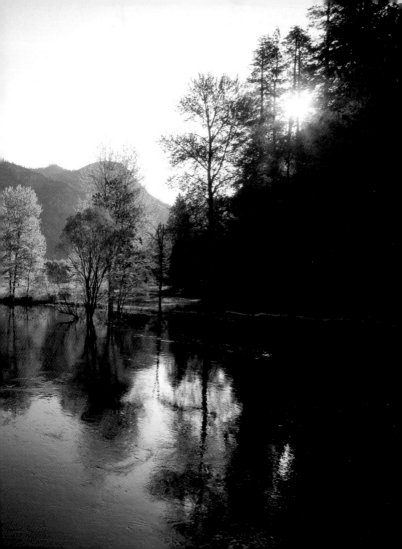

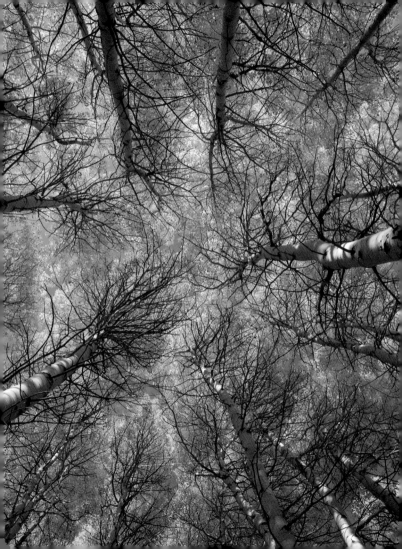

The sweet musty smell of fall is …
a fragrance of aspen dust and honey
and sunshine. The silence is soft
and warm and full, between
intermittent rustlings of gold tissue-
paper, wrapping up the glow of
summer.

—ANN ZWINGER

Quaking aspen grove
Next spread: Spotted Owl mother and young

The surest way
to simplify your life
is to focus on
what matters most.

—DANIELLE LAPORTE

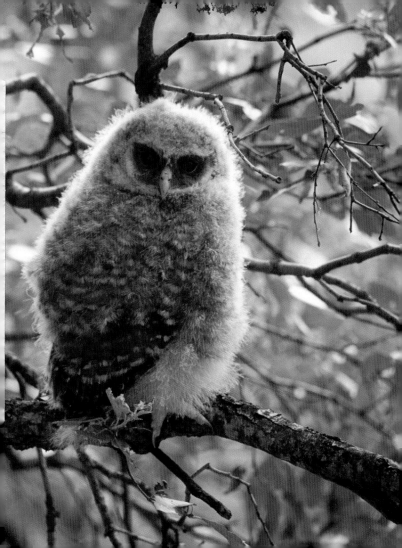

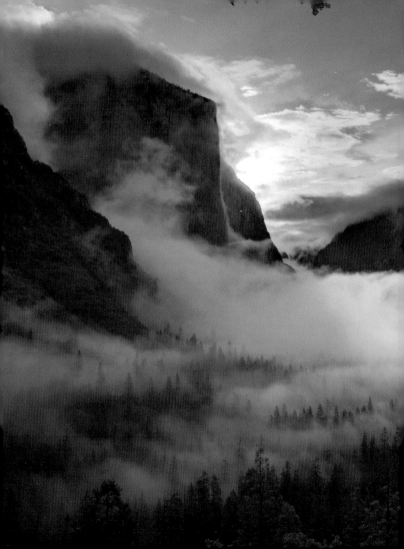

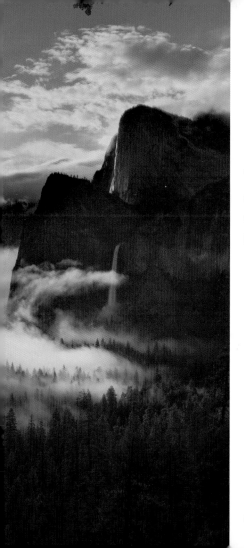

The world is grand,
awfully big, and
astonishingly beautiful,
frequently thrilling.

—DOROTHY KILGALLEN

Sunrise from Tunnel View

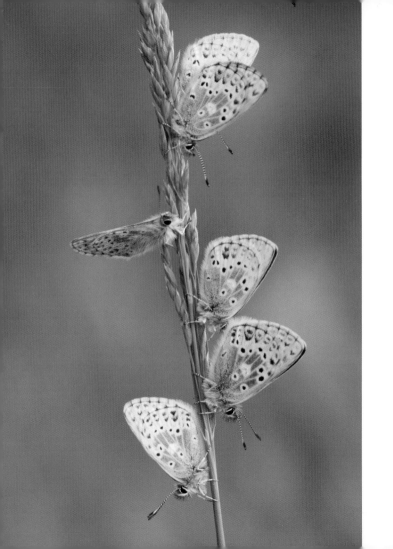

Be faithful in small things
because it is in them
that your strength lies.

—MOTHER TERESA

Moths and grass

Wonder is the heaviest element on the periodic table.
Even a tiny fleck of it stops time.

—DIANE ACKERMAN

Middle Gaylor Lake at sunset

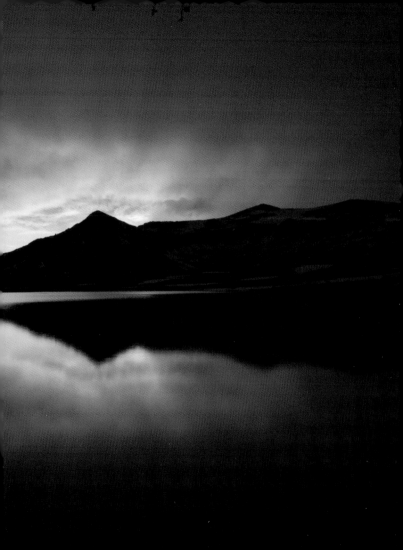

If we make our goal to live a life of
compassion and unconditional love,
then the world will indeed become
a garden where all kinds of flowers
can bloom and grow.

—ELISABETH KÜBLER-ROSS

Coneflowers, Crane Flat

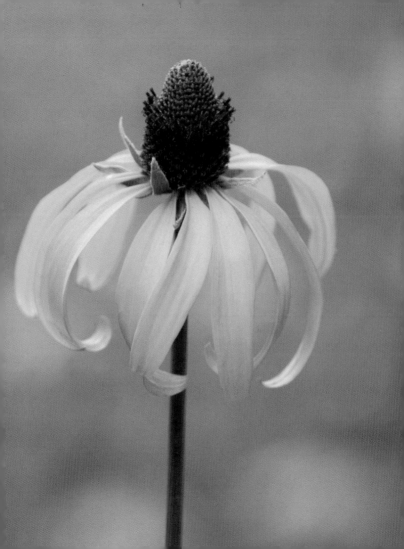

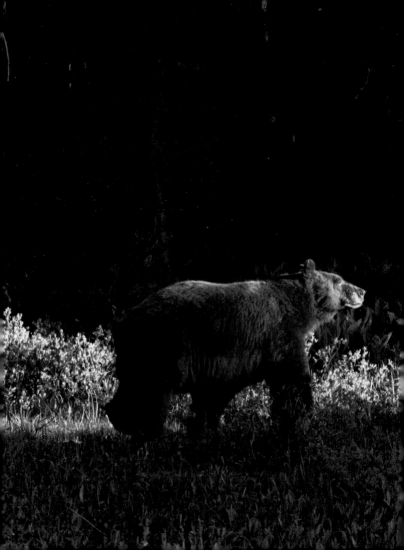

Save something wild, if only your imagination.

—BONNIE GISEL

Black bear, late afternoon

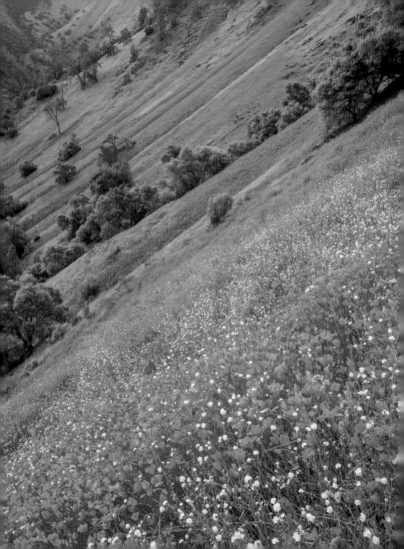

… the frontier is still all around us.
There is still a lot to be discovered.

—ALISON COLWELL

Sun breaking through mist, Tuolumne Meadows
Next spread: Curious mule deer does, Cooks meadow

We ourselves feel that what we are doing
is just a drop in the ocean.
But the ocean would be less because of
that missing drop.

—MOTHER TERESA

Sometimes the most important thing in a whole day

is the rest we take between two deep breaths.

—ETTY HILLESUM

A human mind is small when thinking
of small things.
It is large when embracing the maker
of walking, thinking and flying.

—JOY HARJO

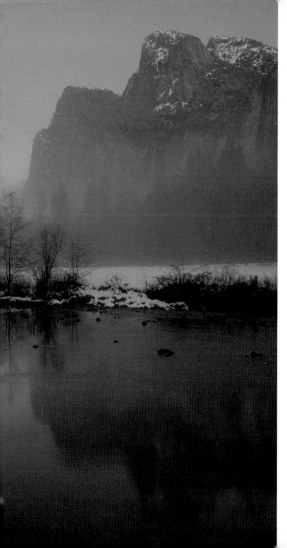

Rising Moon,
Gates of the Valley

Next spread: Painter
at Valley View

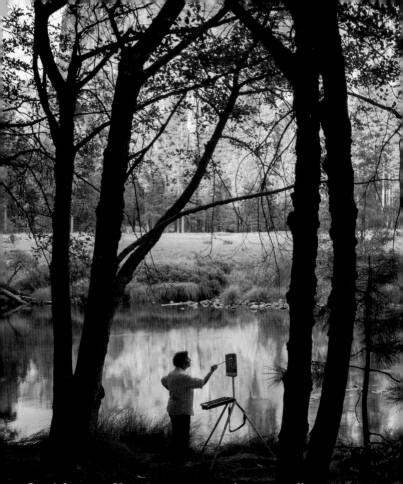

One lifetime in Yosemite is not enough to see it all—

it is always different. And I'm different each time I paint it.

—PENNY OTWELL

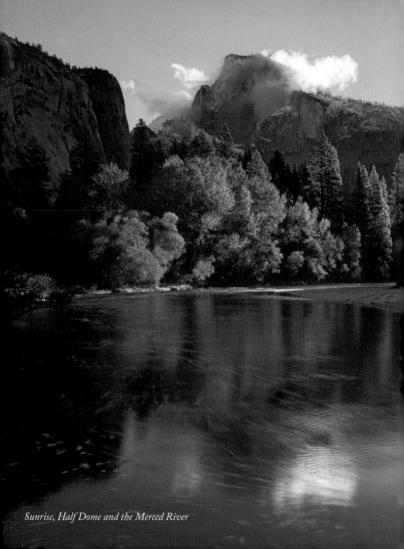

Sunrise, Half Dome and the Merced River

Faraway there in the sunshine are my highest aspirations. I may not reach them, but I can look up and see their beauty, believe in them, and try to follow where they lead.

—LOUISA MAY ALCOTT

The Universe has a plan to make sure
we don't ever stop learning, not only
in our minds, but also in our hearts.

—PAM HOUSTON

SOURCES

Ackerman, Diane, *A Natural History of the Senses.* New York: Vintage Books, 1995. Used with permission. *It began in mystery …*

Ackerman, Diane, *Dawn Light,* 1st ed. New York: W.W. Norton & Company, Inc, 2009. Used with permission. *Wonder is the heaviest element …*

Alcott, Louisa May, *Work: A Story of Experience.* New York: Penguin Group, 1994. First published by the Roberts Brothers, 1873.

Anderson, Lorraine, *Sisters of the Earth: Women's Prose and Poetry About Nature,* 2nd ed. New York: Vintage Books, 2003. Used with permission.

Angelou, Dr. Maya, *A Letter to My Daughter.* New York: Random House, Inc., 2008. *… I can never forget …*

Angelou, Dr. Maya, *Wouldn't Take Nothing for My Journey Now.* New York: Bantam Books, 1994. *It is this belief in a power…*

Beck, Martha, "Martha Beck's 7 Steps to Creating the Life You Really Want," in "Find Your Passion," www.oprah.com, May 16, 2012.

Bernhard, Ruth, *Ruth Bernhard: The Eternal Body: A Collection of Fifty Nudes,* 1st ed. Carmel, CA: Photography West Graphics, 1986.

Browning, Elizabeth Barrett, *Aurora Leigh.* London: Chapman and Hall, 1860.

Cashner, Annie Barrett, from an original poem, "If the earth laughs in flowers … Ode to Emerson." Foresta, Yosemite National Park, 2000. Used with permission.

Colwell, Alison, video interview, "Sky Islands," *Nature Notes* Episode 16, produced by the National Park Service and Yosemite Conservancy. Used with permission. Botanist, National Park Service, Yosemite National Park.

Curie, Marie, *Pierre Curie.* Trans. by Charlotte Kellogg and Vernon Lyman Kellogg. New York: Macmillan Co., 1923.

Duse, Eleonora, "Eleanora Duse Quotes," www.brainyquote.com.

Ehrlich, Gretel, *Islands, the Universe, Home.* New York: Penguin Books, 1991.

Gisel, Bonnie, personal statement, used with permission. Curator, LeConte Memorial Lodge, Yosemite National Park. *Write your story, sing your story ...*

Gisel, Bonnie, personal statement, used with permission. Curator, LeConte Memorial Lodge, Yosemite National Park. *Save something wild ...*

Greenwood, Grace, *New Life In New Lands: Notes of Travel.* New York: J. B. Ford & Company, 1873. It seemed to me ...

Harjo, Joy, "Fire," *How We Became Human,* 1st ed. New York: W. W. Norton & Company, 2002. Used with permission. *A woman can't survive ...*

Harjo, Joy, "Emergence," *A Map to the Next World: Poems and Tales.* Reprint, New York: W.W. Norton & Company, 2001. Used with permission. *A human mind is small ...*

Hillesum, Etty, used with the permission of the Etty Hillesum Research Centre of Ghent University. Amsterdam: Balans Publishing House.

Houston, Pam, *Woman's Best Friend: Women Writers on the Dogs in Their Lives.* Emeryville, CA: Seal Press, 2005. Used with permission.

Kilgallen, Dorothy, *Girl Around the World.* Philadelphia: David McKay Company, 1936.

Kübler-Ross, Elisabeth, used with permission from the Elisabeth Kübler-Ross Foundation, Scottsdale, AZ. *Should you shield the canyons ...*

Kübler-Ross, Elisabeth, used with permission of the Elisabeth Kübler-Ross Foundation, Scottsdale, AZ. *If we make our goal to live a life ...*

LaPorte, Danielle, "Truthbomb #11" from "White Hot Truth and Other Sermons," www.daniellelaporte.com. *You're not broken ...*

LaPorte, Danielle, "Truthbomb #80" from "White Hot Truth and Other Sermons," www.daniellelaporte.com. *The surest way to simplify your life ...*

Mauk, Charlotte, "Homecoming, 1946." *Sierra Club Bulletin* 32, no. 5 (May 1947). Used with permission.

Millay, Edna St. Vincent, "Afternoon on a Hill," *Renascence and Other Poems,* New York: Harper, 1917. Used with permission of the Edna St. Vincent Millay Library, Austerlitz, NY.

Mother Teresa, in her own words. The writings of Mother Teresa of Calcutta © by the Mother Teresa Center, exclusive licensee throughout the world of the Missionaries of Charity for the works of Mother Teresa, used with permission. *Be faithful in small things ...*

Mother Teresa, in her own words. The writings of Mother Teresa of Calcutta © by the Mother Teresa Center, exclusive licensee throughout the world of the Missionaries of Charity for the works of Mother Teresa, used with permission. *We ourselves feel …*

Nin, Anaïs, quote used with permission of the Anaïs Nin Trust. All rights reserved. *Dreams are necessary to life.*

Nin, Anaïs, "Risk." Used with permission of the Anaïs Nin Trust. All rights reserved. *And the day came …*

O'Neill, Elizabeth Stone, *Meadow in the Sky,* 3rd ed. Groveland, CA: Albicaulis Press, 1993.

Otwell, Penny, personal statement, used with permission. Artist and naturalist, Mariposa, CA.

Owings, Margaret, *"Facets of Wilderness." Sierra Club Bulletin* 50, no. 10 (December 1965).

Parker, Julia, personal statement, used with permission. Indian Cultural Demonstrator, National Park Service, Yosemite National Park.

Potocky, Shauna, personal interview, used with permission. Branch Chief of Education, National Park Service, Yosemite National Park.

Pratt, Beth, personal journal entry from "Beth's Excellent Adventures," July 28, 2012, www.bethpratt.com. Used with permission.

Rowling, J.K., *Harry Potter and the Order of the Phoenix.* Copyright © J.K. Rowling 2003. Used with permission.

Strayed, Cheryl, *Wild: From Lost to Found on the Pacific Crest Trail,* 1st ed. New York: Alfred A. Knopf, 2012. Used with permission.

West, Mae, "Mae West Quotes," www.finestquotes.com. Used with permission.

Williamson, Marianne, *A Return to Love.* New York: HarperCollins Publishers, 1992. Used with permission.

Zwinger, Ann, *Beyond the Aspen Grove.* Boulder, CO: Johnson Books, 2002. First published by Random House.

Zwinger, Susan and Ann Zwinger, *Women in Wilderness,* 1st Edition. Del Mar, CA: Tehabi Books/Harcourt Brace & Company, 1995. Used with permission. *I go into the wilderness …*

Zwinger, Susan and Ann Zwinger, *Women in Wilderness,* First Edition. Tehabi Books, Harcourt Brace & Company, 1995. Used with permission. *Each woman goes out …*

For my mother, who loved books and taught me to love them, too.
And for the Yosemite moms—your friendship
has meant the world to me. —CW

Yosemite Conservancy's Mission—
Providing for Yosemite's future is our passion. We inspire people to support projects and programs that preserve and protect Yosemite National Park's resources and enrich the visitor experience.

Library of Congress Control Number: 2012946780

Cover photograph: Michael Frye
Cover design: Nancy Austin
Interior design: Nancy Austin

ISBN 978-1-930238-40-4

Printed in Singapore by Tien Wah Press

1 2 3 4 5 6 – 17 16 15 14 13

YOSEMITE CONSERVANCY.

yosemiteconservancy.org